Chesley, Ontario in Photos, Saving Our History One Photo at a Time

Photography
by Barbara Raué
2012

Series Name:
Cruising Ontario

Book 5: Chesley

Cover photo taken on 1st Avenue South

Chesley, Ontario

Sconeville was the name of the settlement that developed here following the erection of mills on the Saugeen River by Adam Elliot in 1858-1859. A post office, named after Solomon Chesley, a former Indian Department official, was established in 1865 and the village took on the name of Chesley. A branch of the Grand Trunk Railway was completed to Chesley in 1881 facilitating its development as a centre for agricultural businesses and the shipment of produce, livestock, lumber and bark.

Chesley is located in Bruce County on Sideroad 30 North; it is north of Walkerton on Bruce Road 19, and north of Hanover on County Road 10.

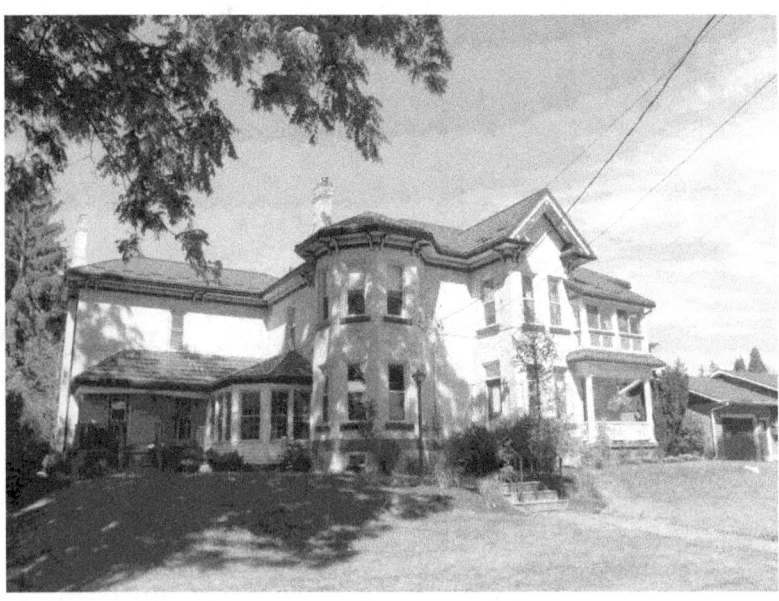

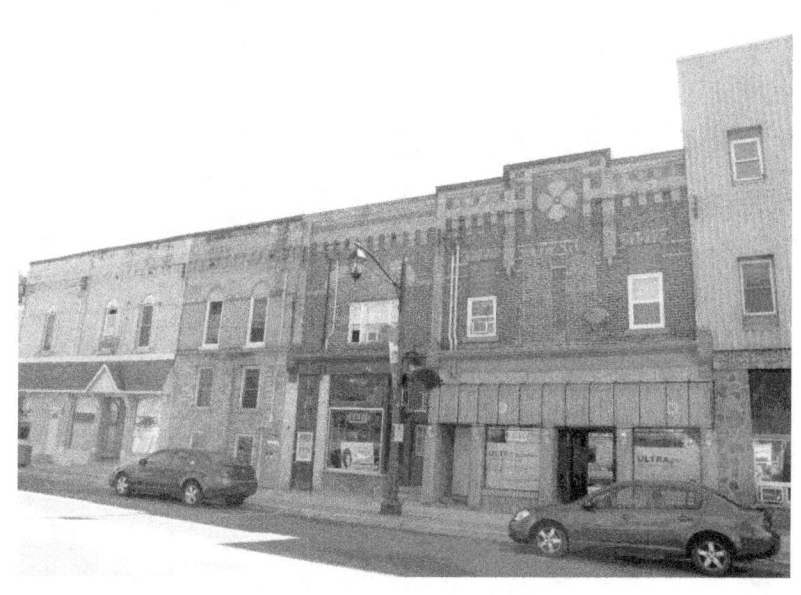

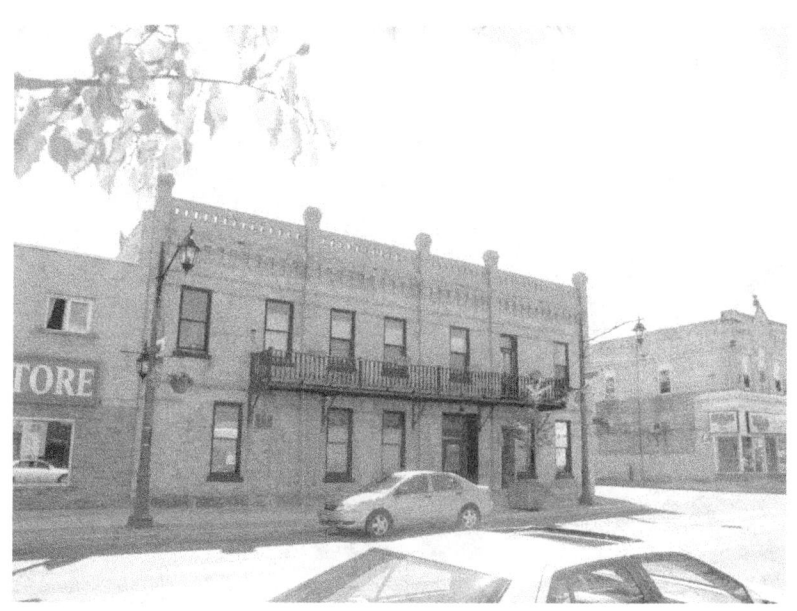

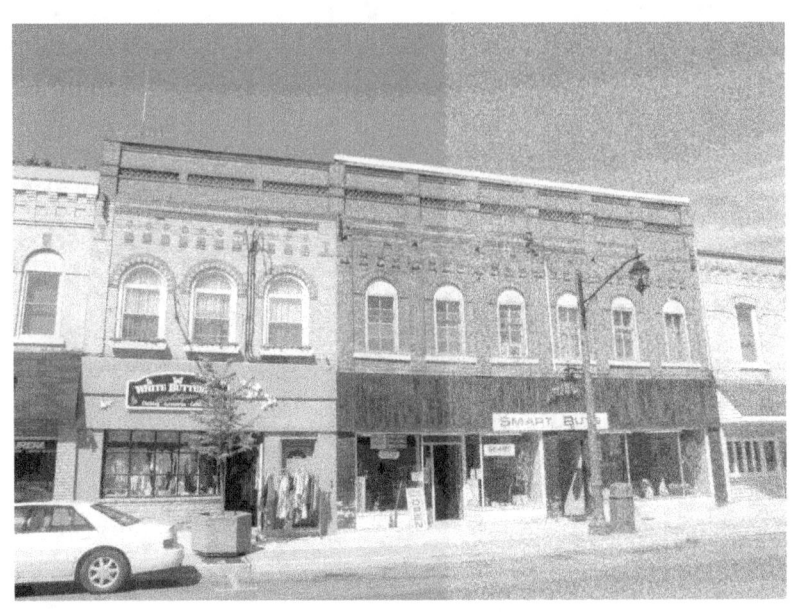

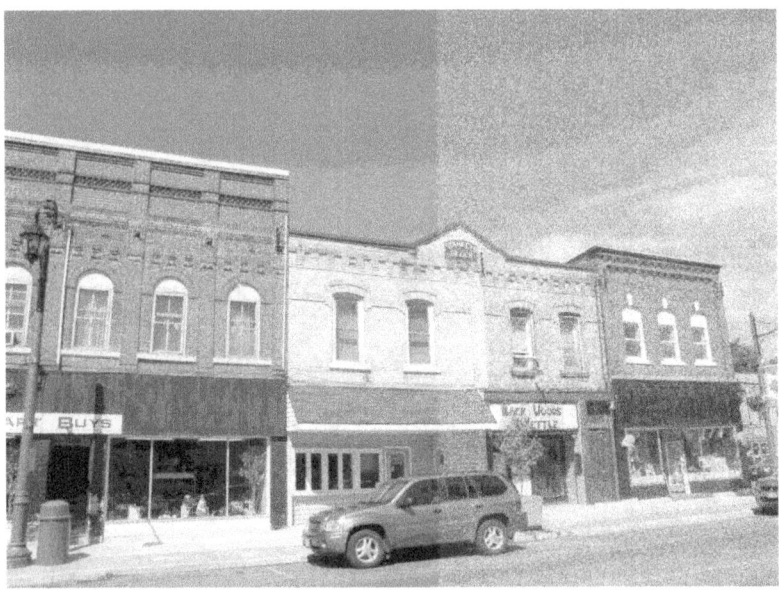

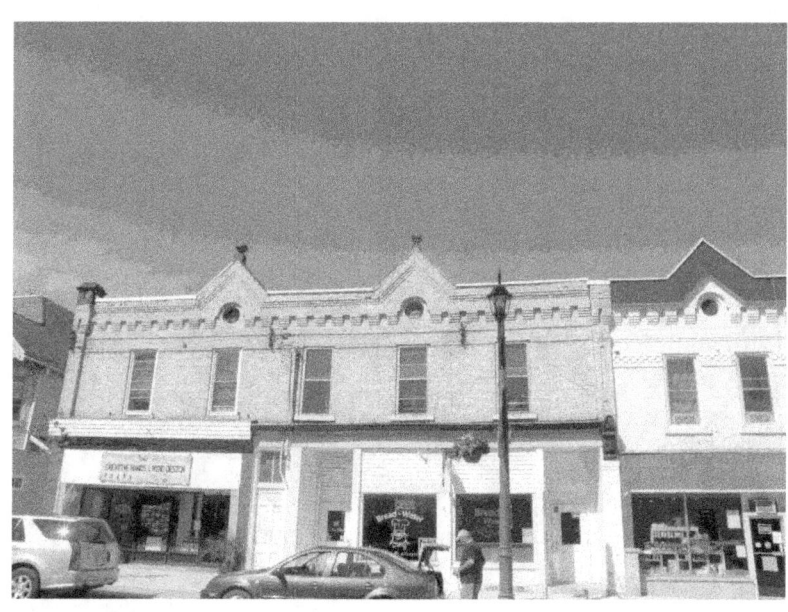

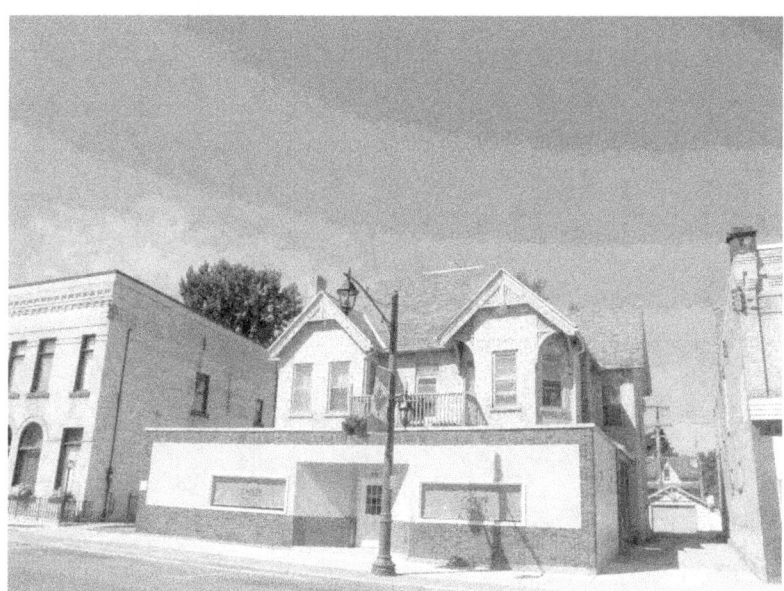

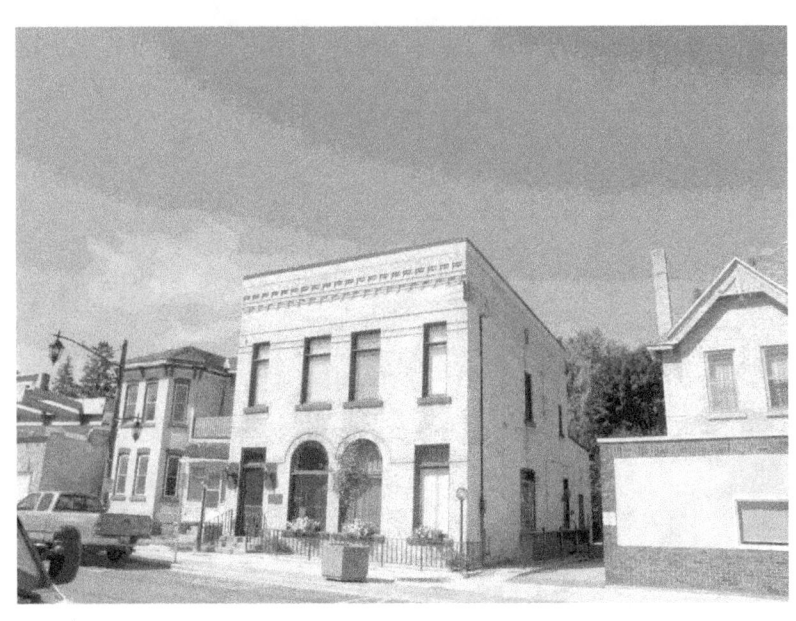

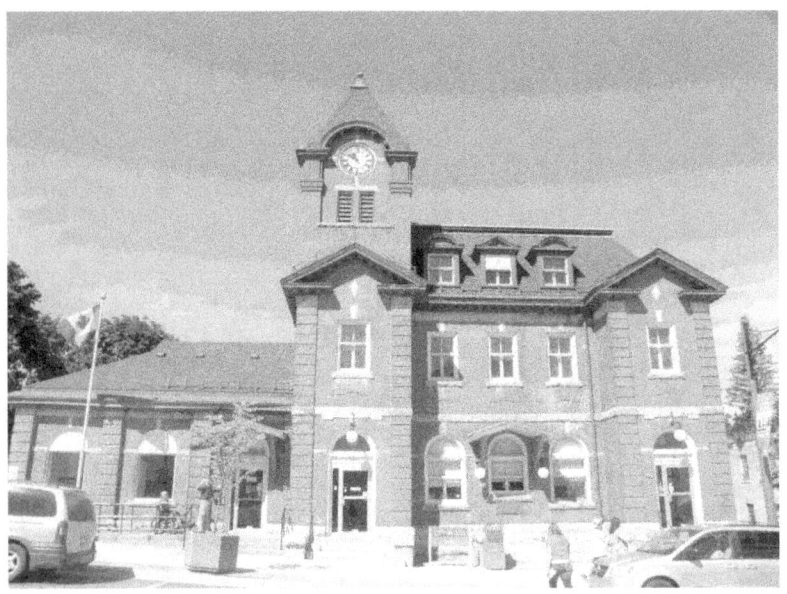

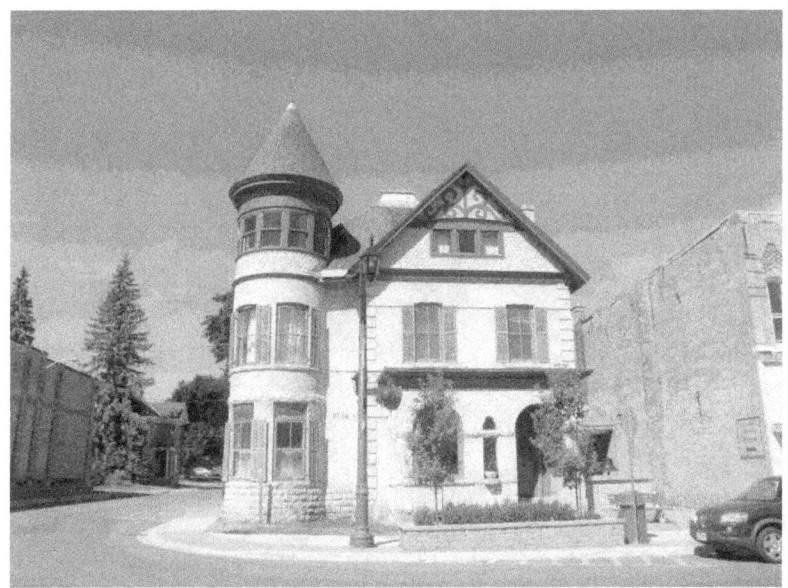

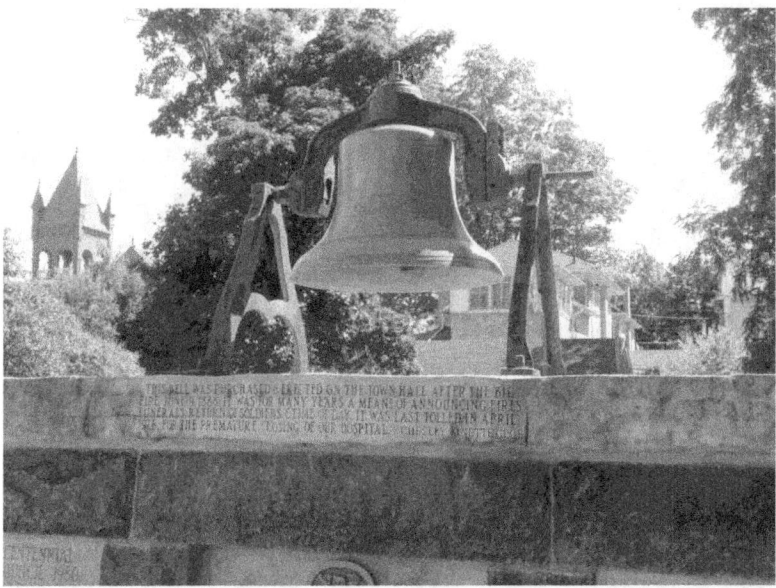

This bell was purchased and erected on the town hall after the big fire of June 9, 1888 which destroyed most of the original downtown core. For many years, the bell was the means of announcing fires, funerals, return of soldiers, and time of day.

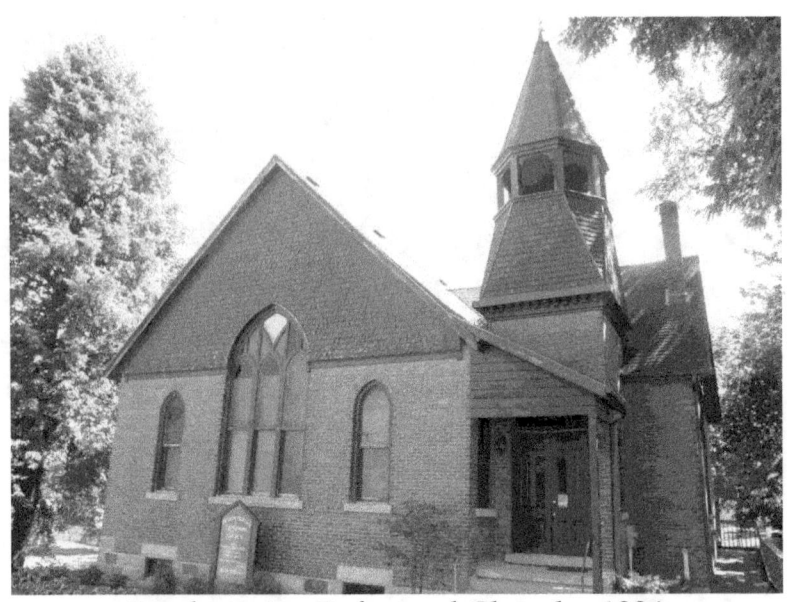
Presbyterian Reformed Church - 1904

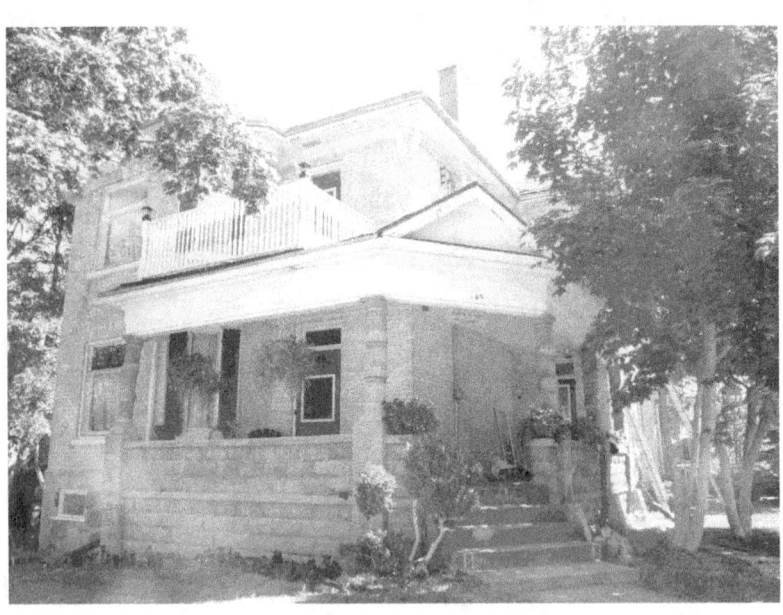

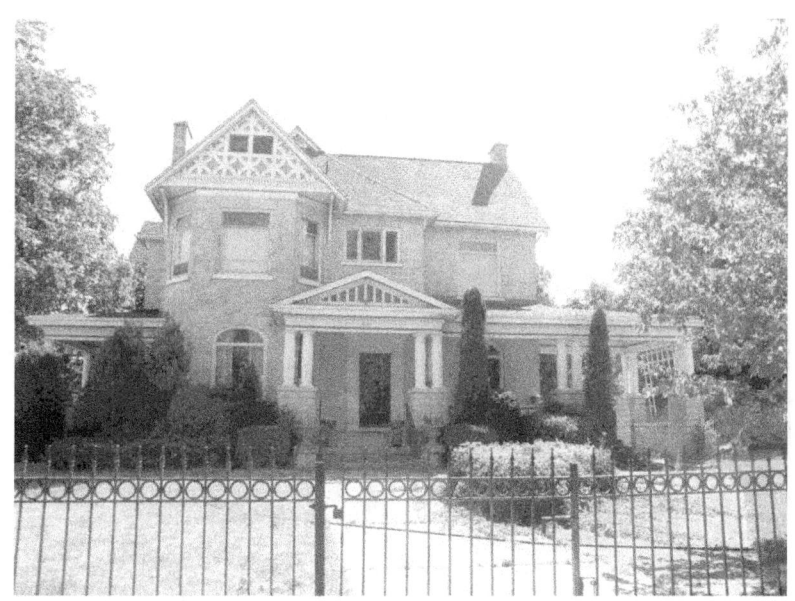

#159

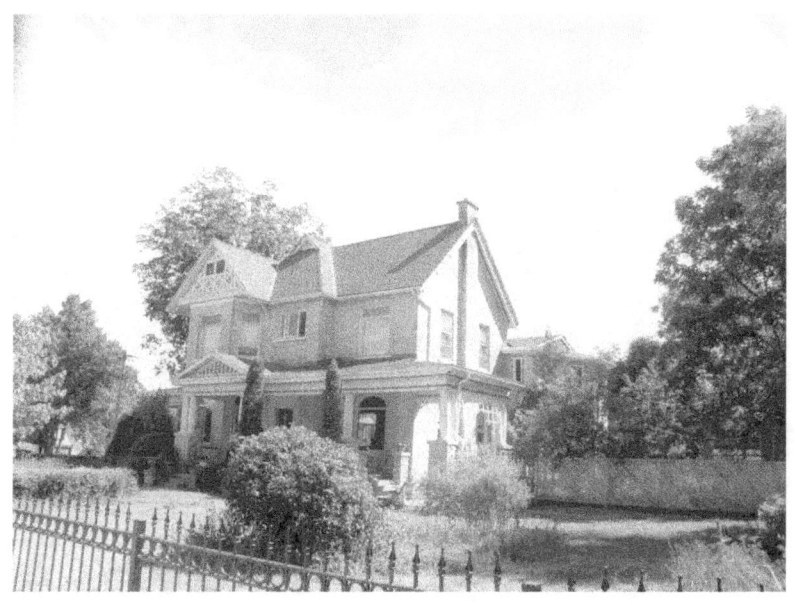

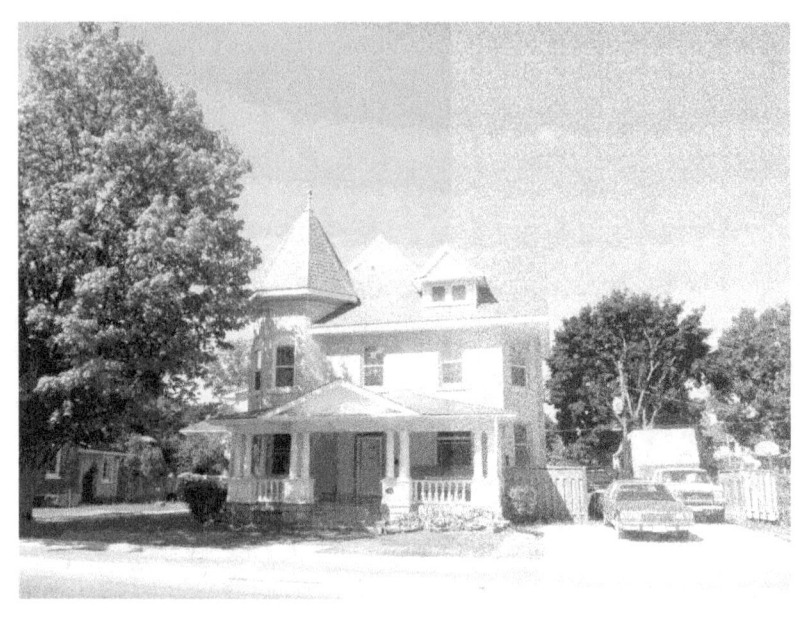

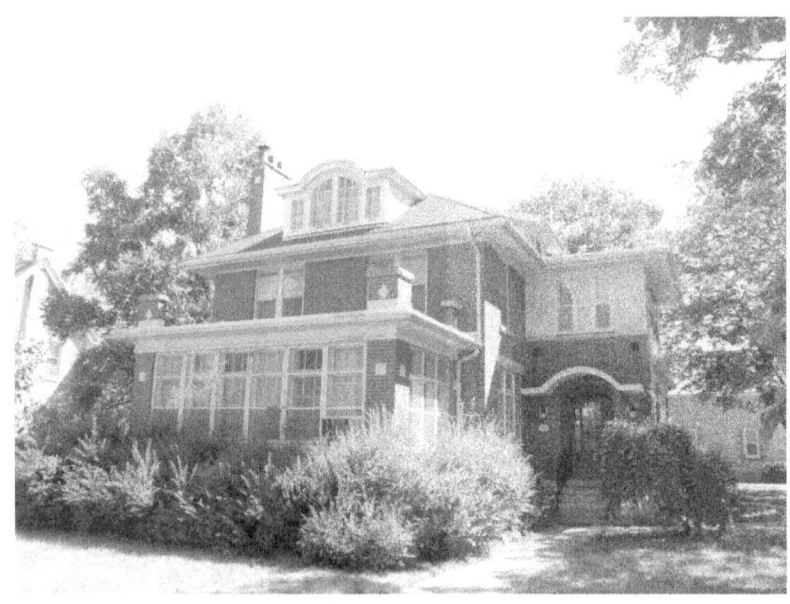

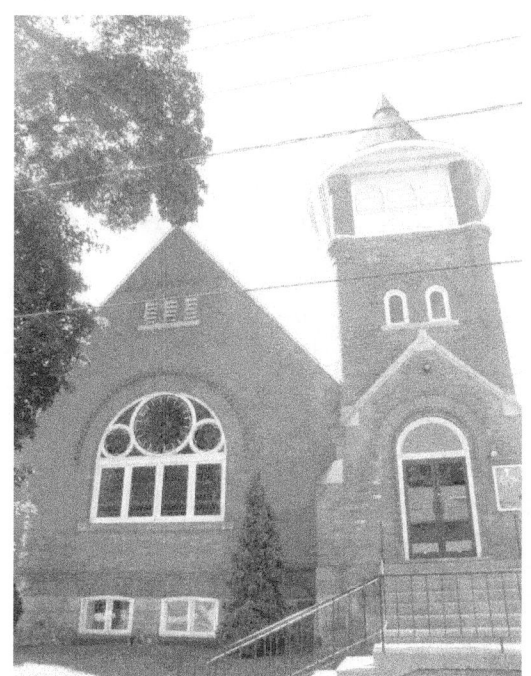

Holy Trinity Anglican Church

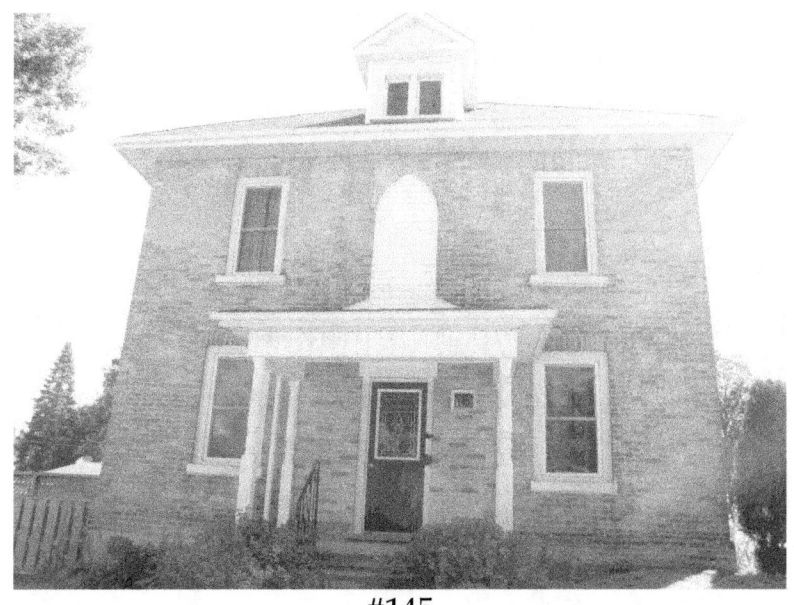

#145

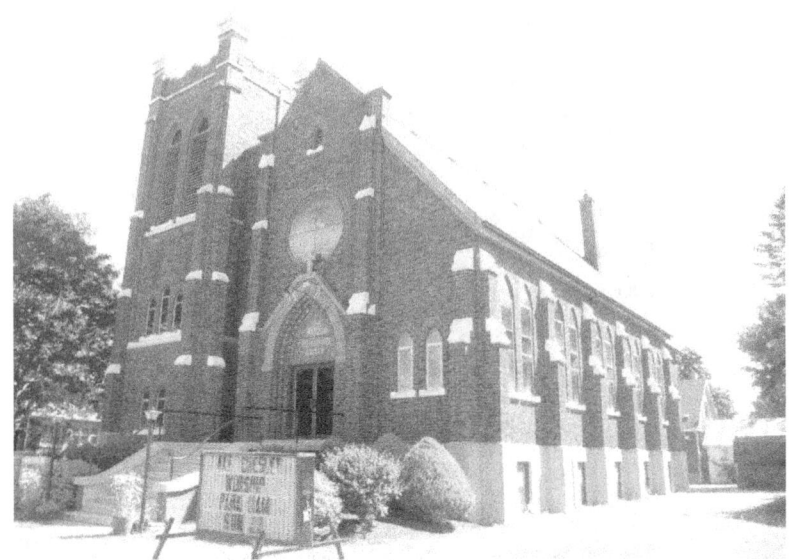

St. Mark's Evangelical Lutheran Church

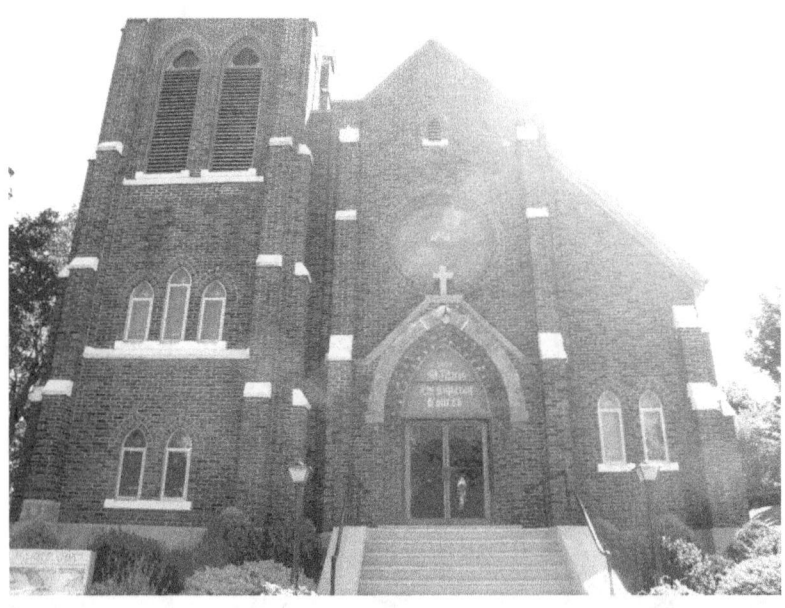

#139

#130

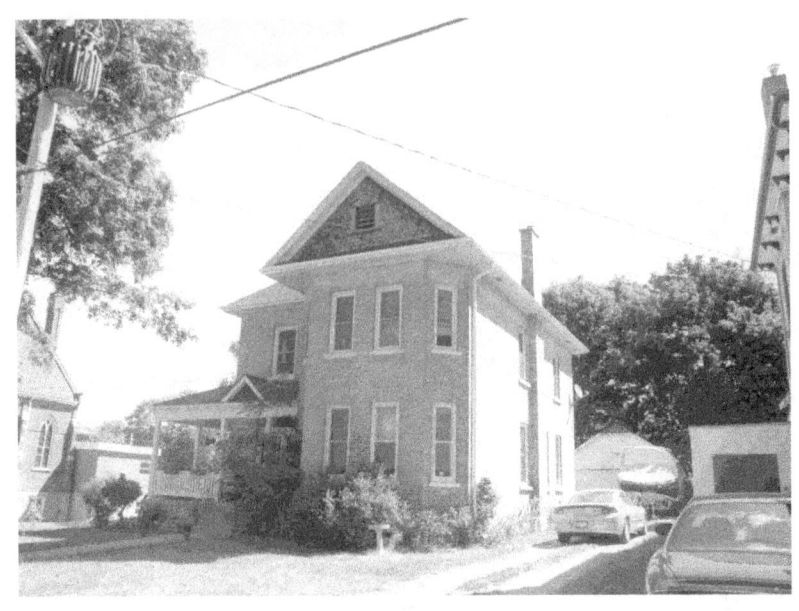

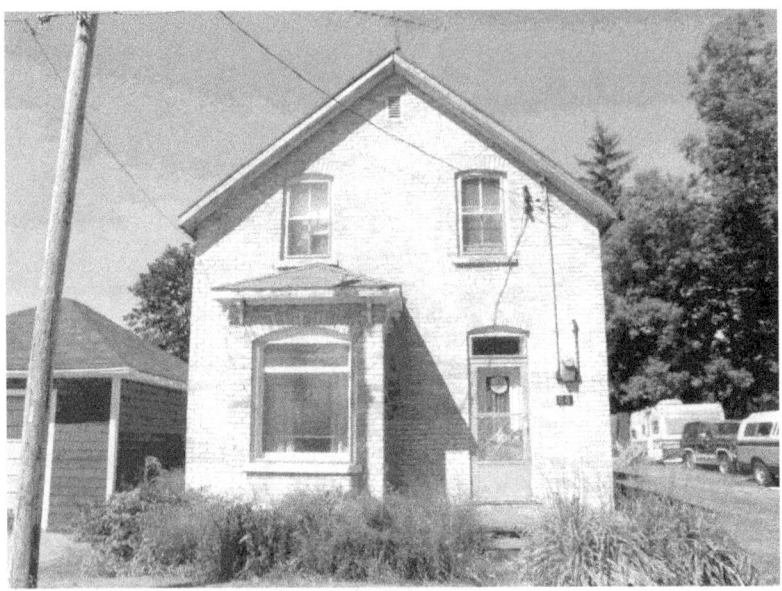

#84

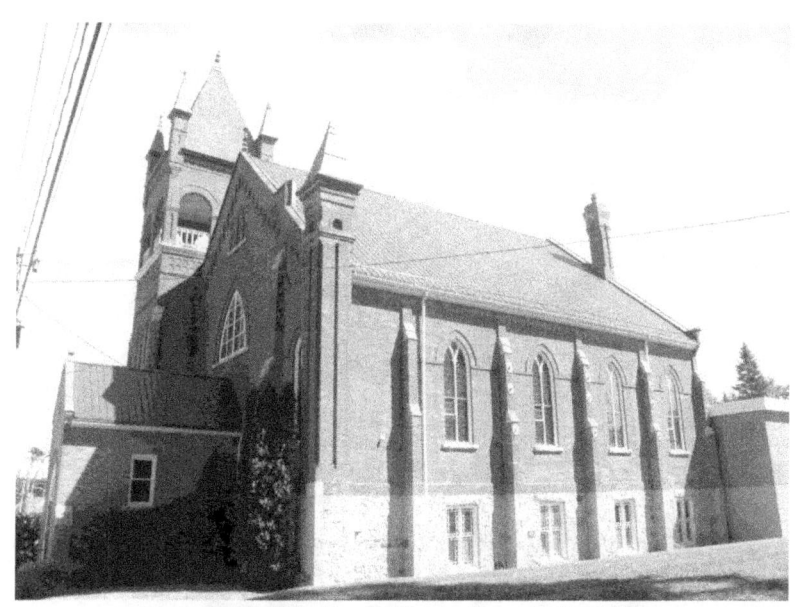

St. John's United Church – A.D. 1889

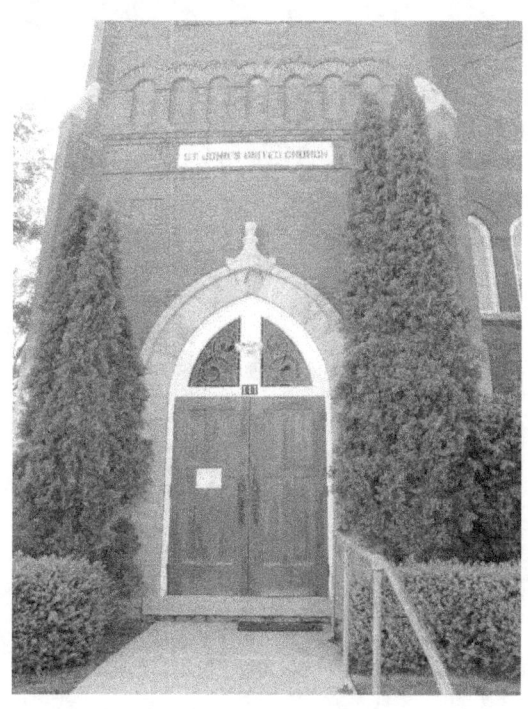

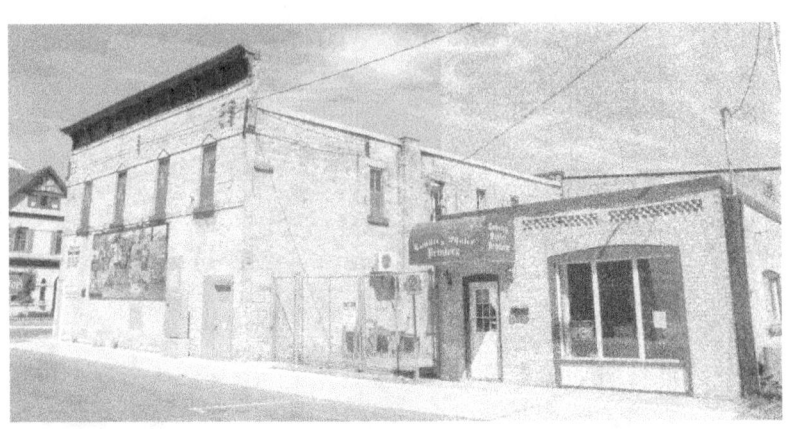

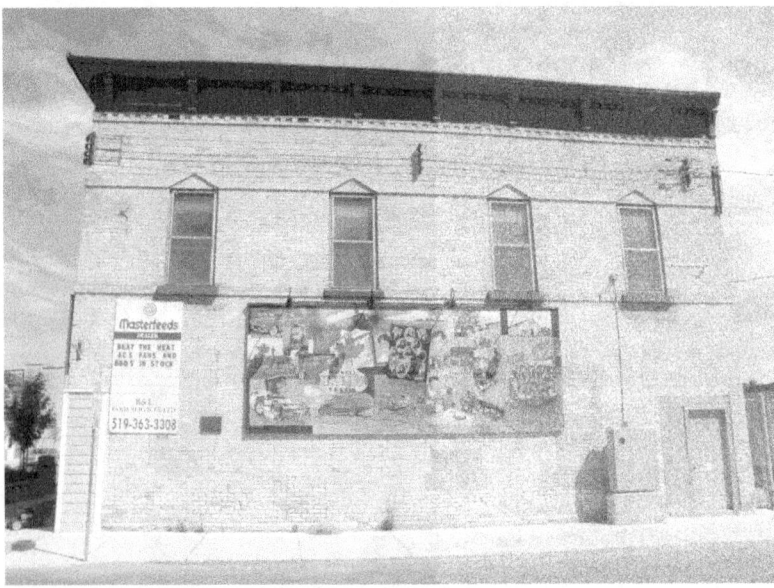

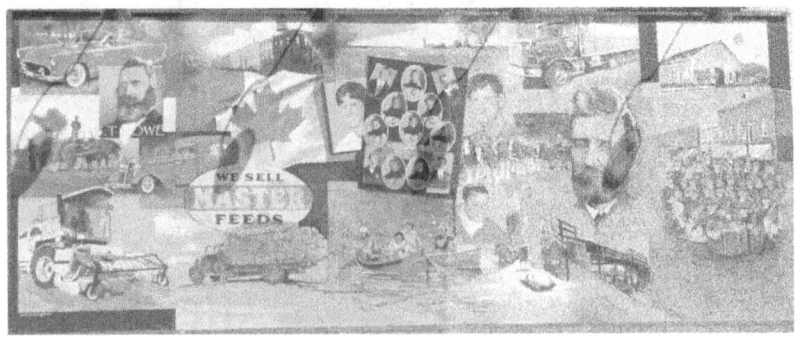

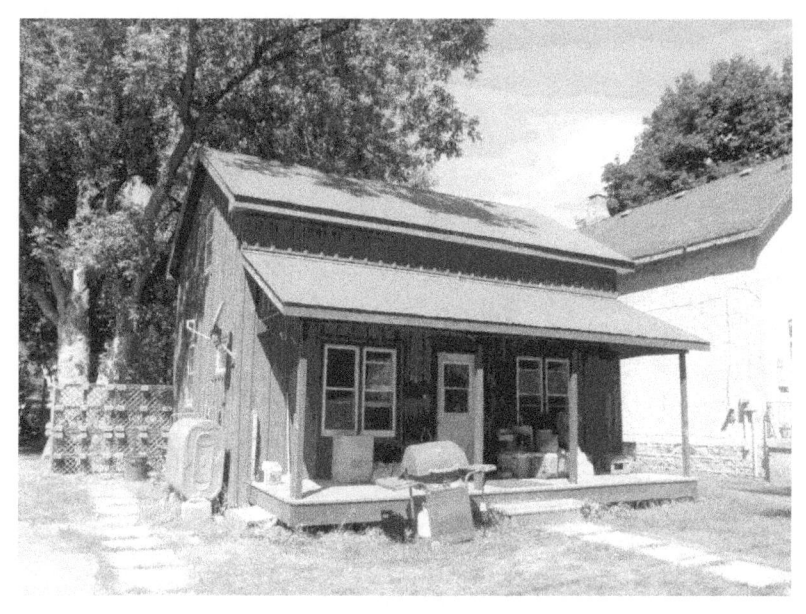

#74

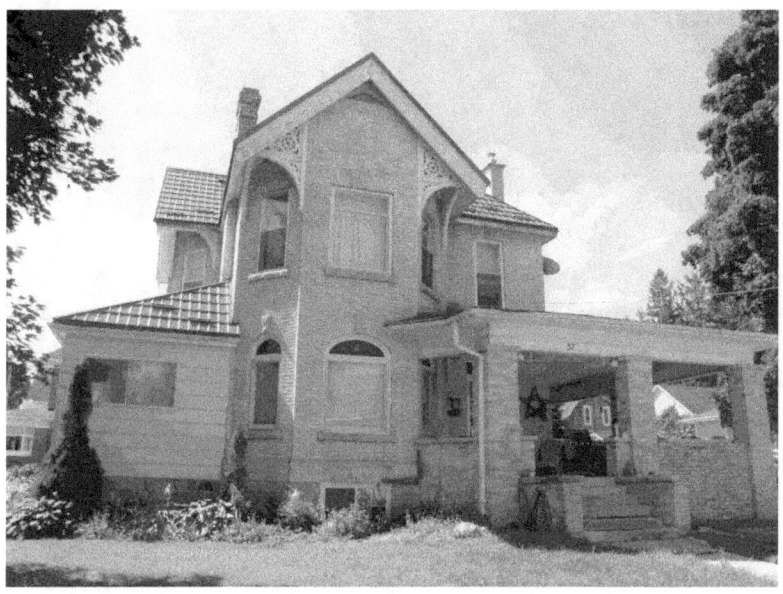

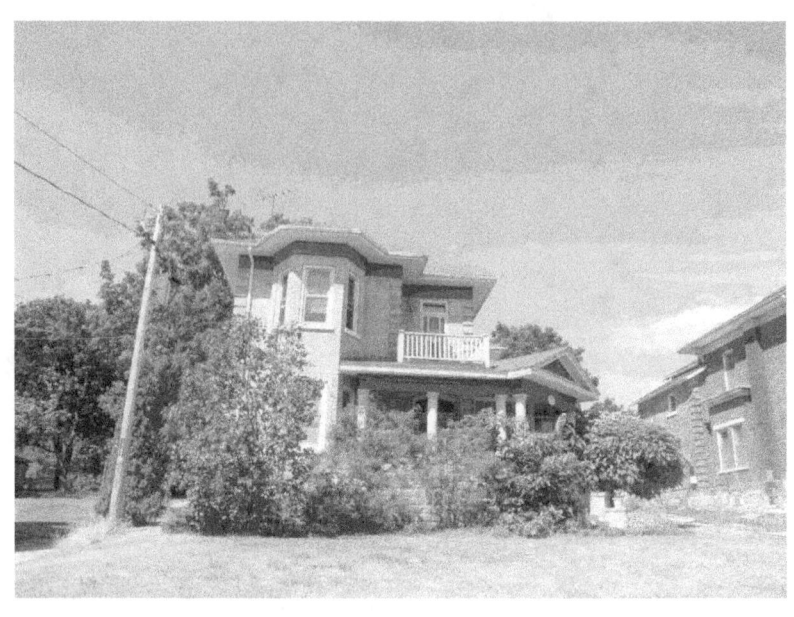

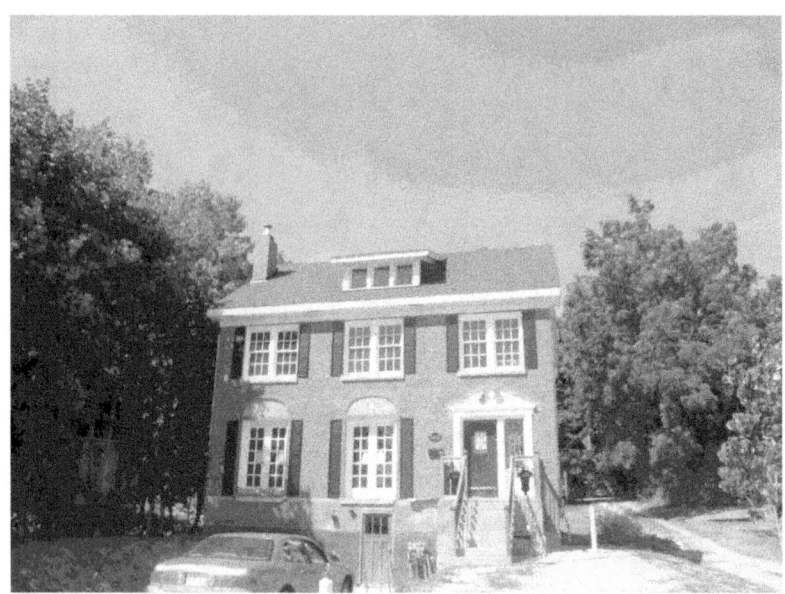

100 5th Avenue

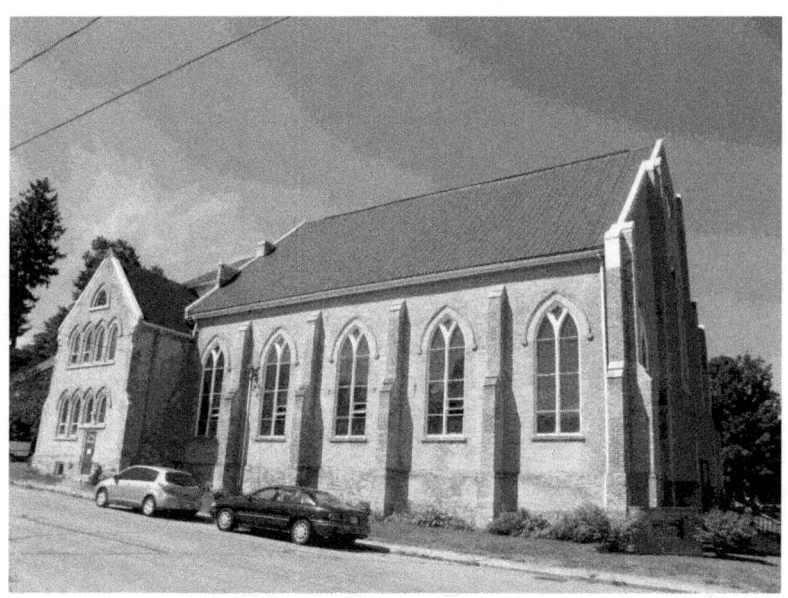

Geneva Presbyterian Church

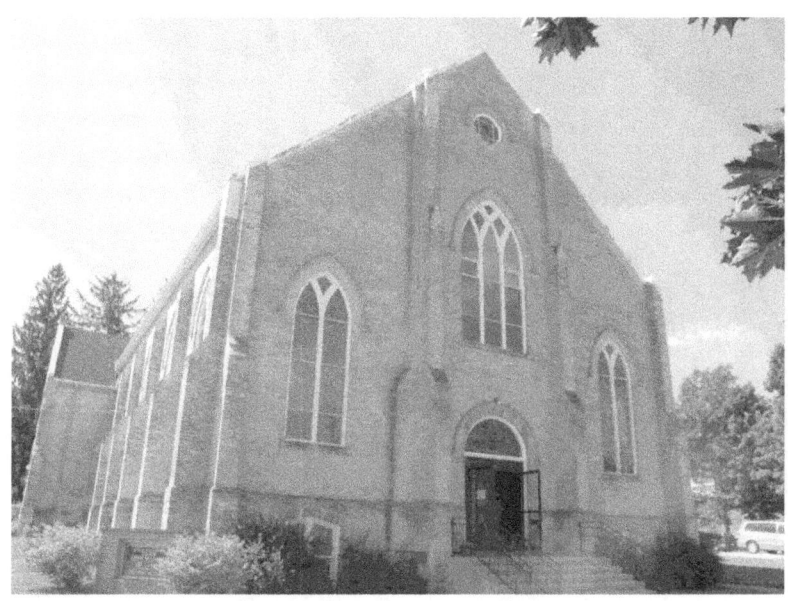

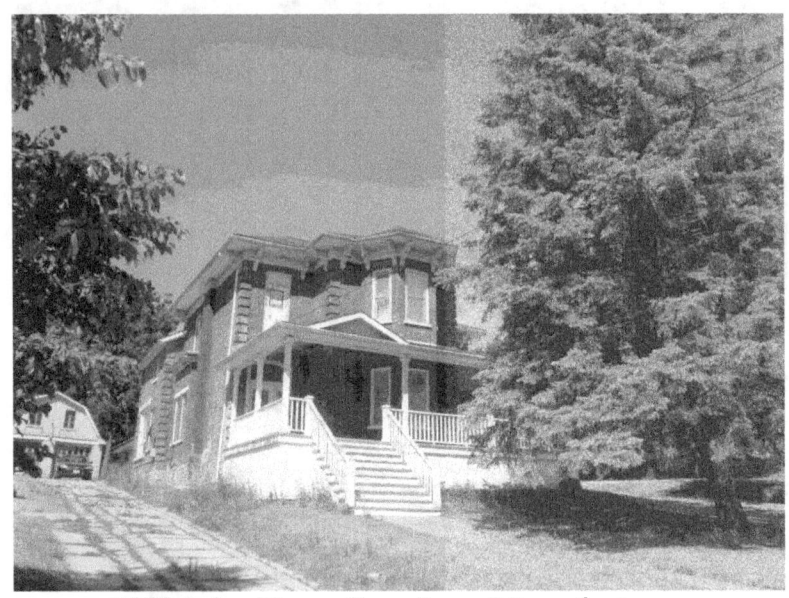

1889 John Krug, Furniture Manufacturer

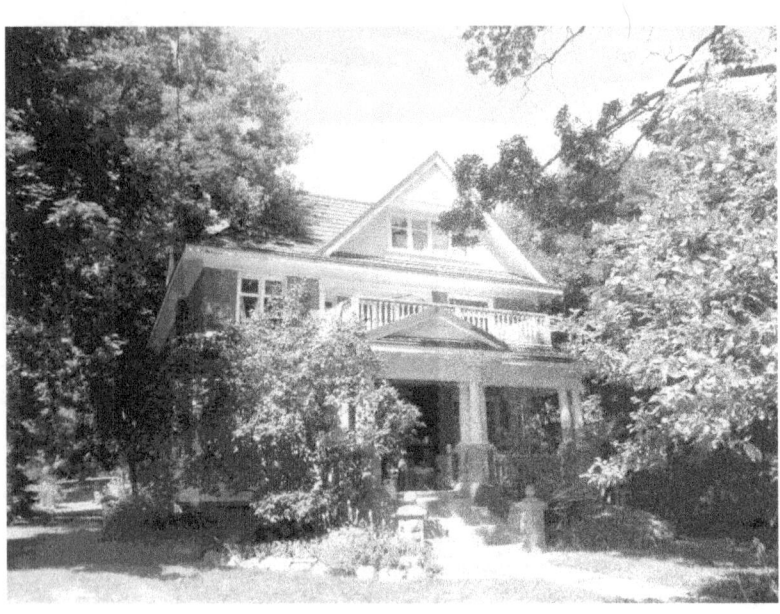

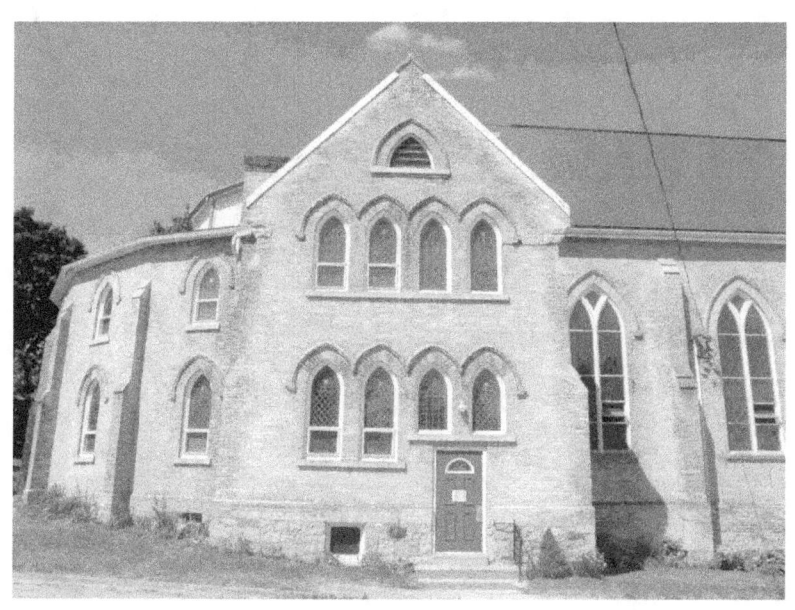

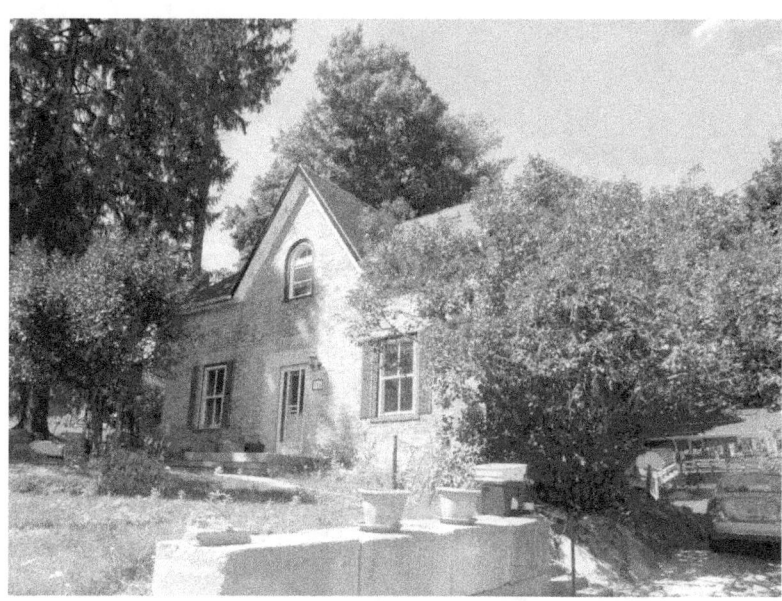

#120

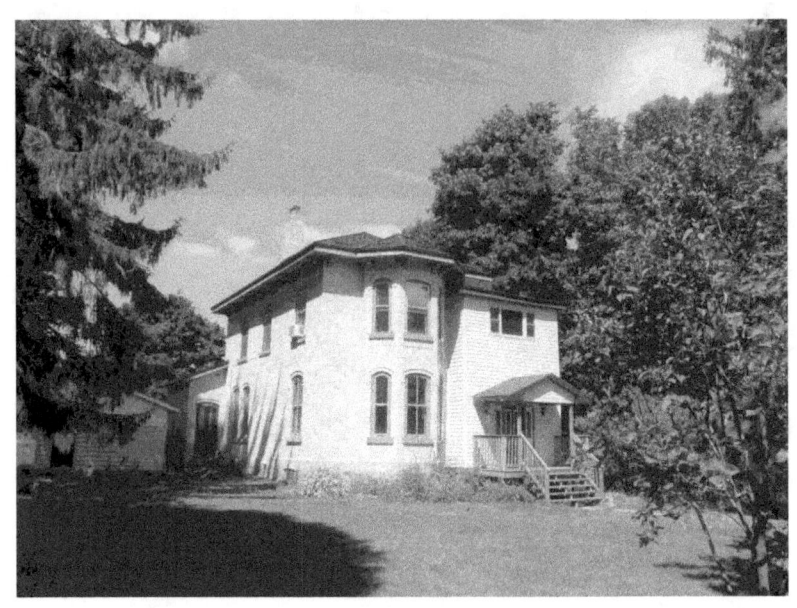

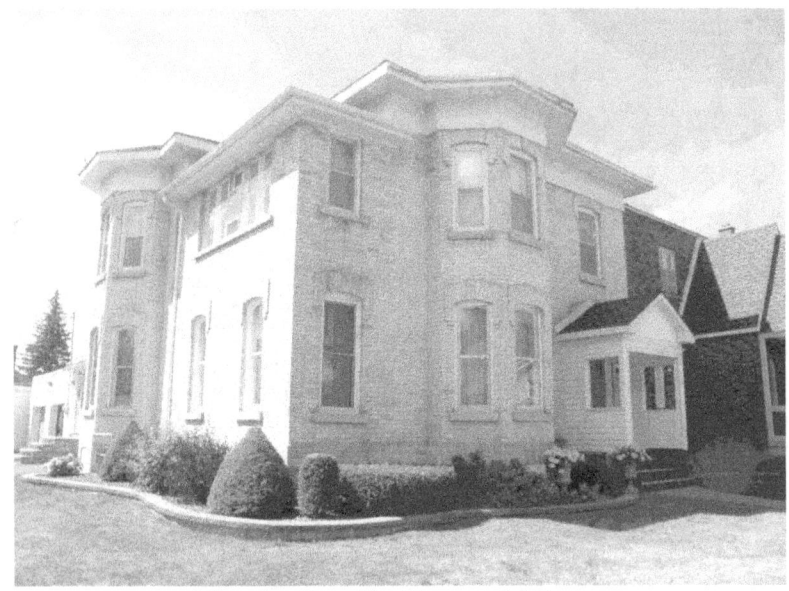

Rhody Family Funeral Home

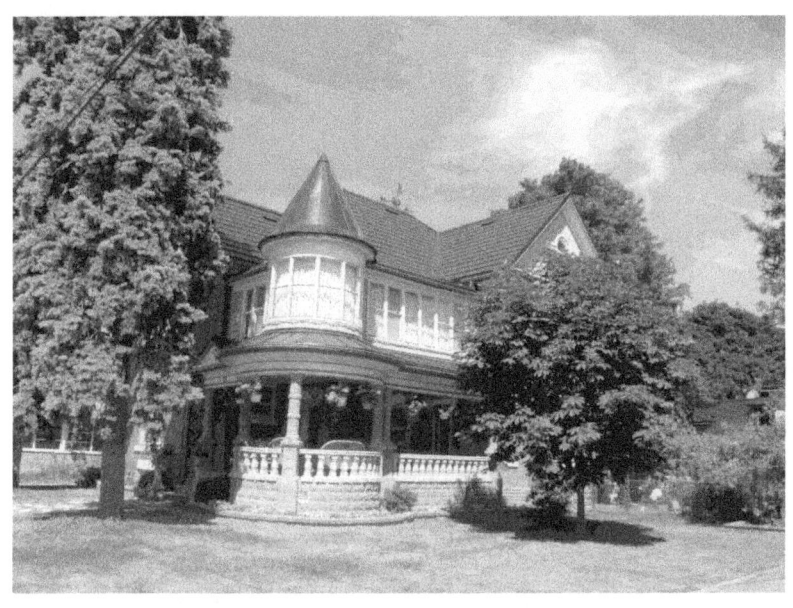

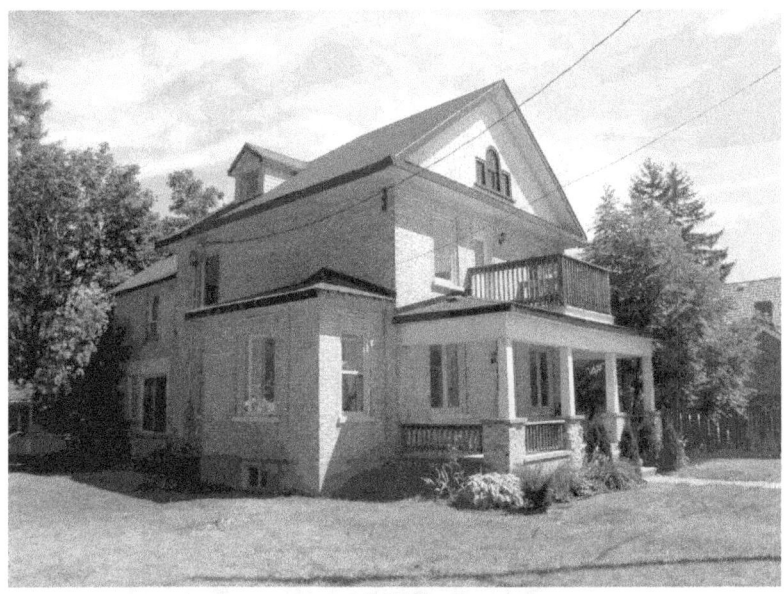

#140

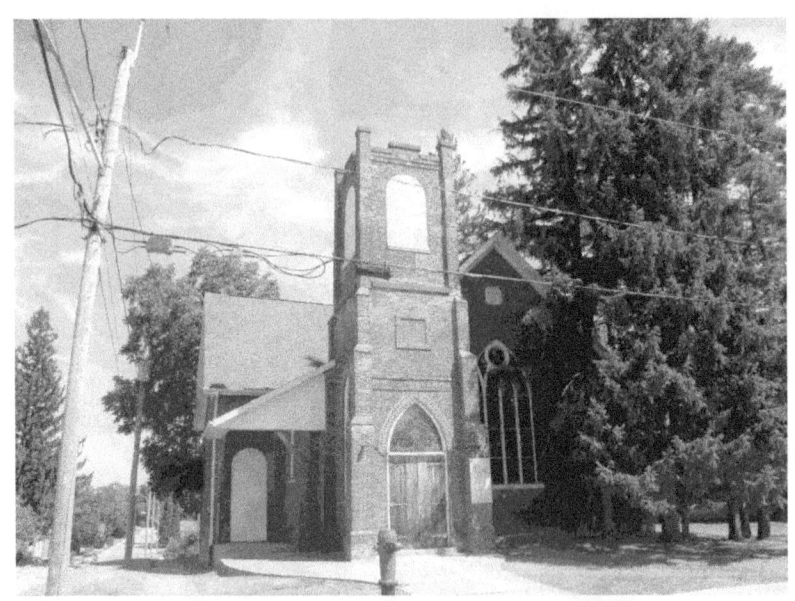

Trinity Evangelical Church - 1889
Ebenezer Free Presbyterian Church of Scotland

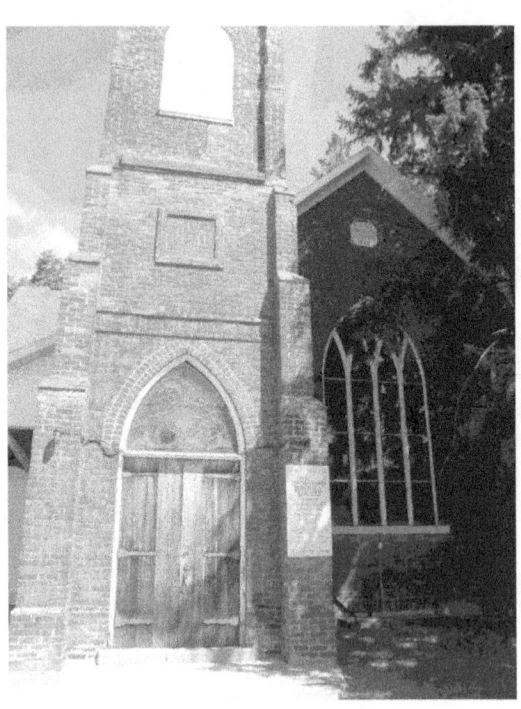

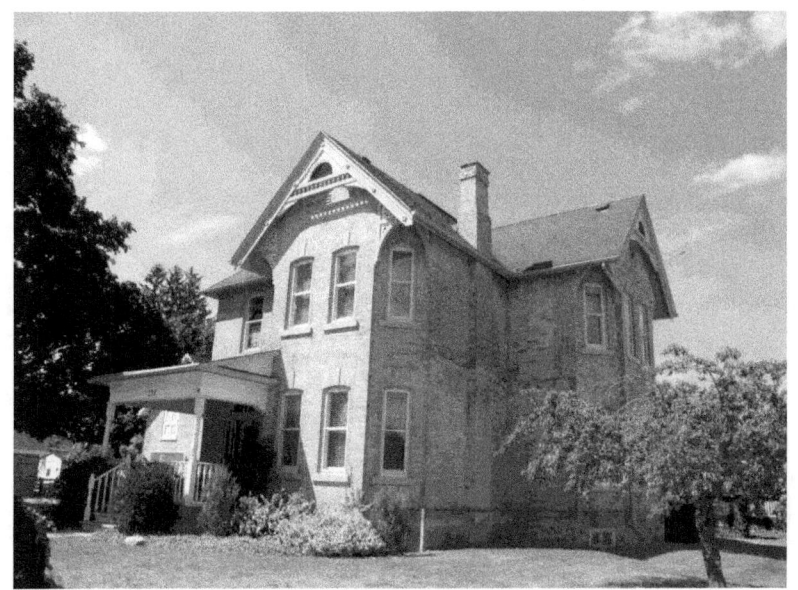

#152

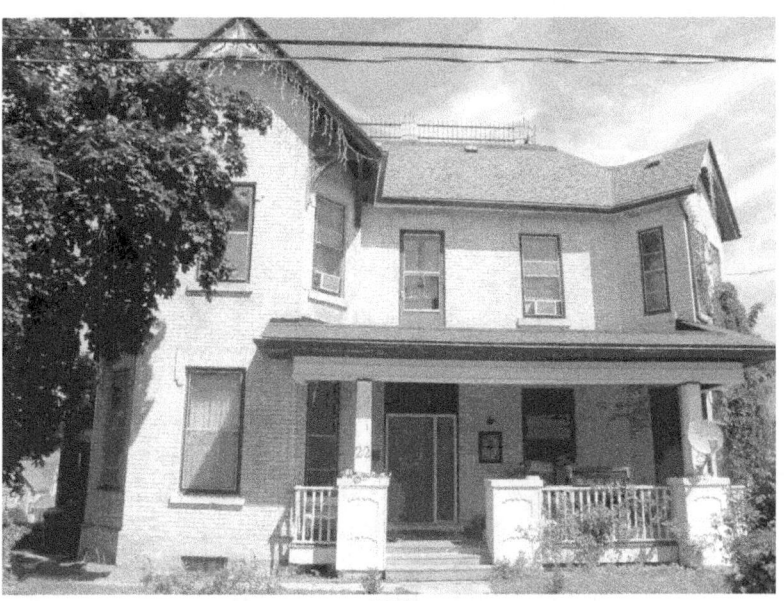

#22

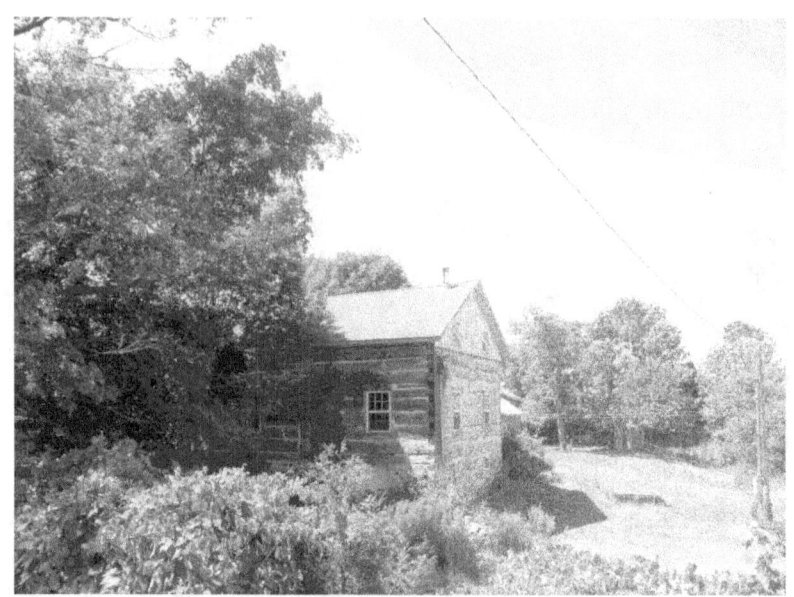

Log cabin

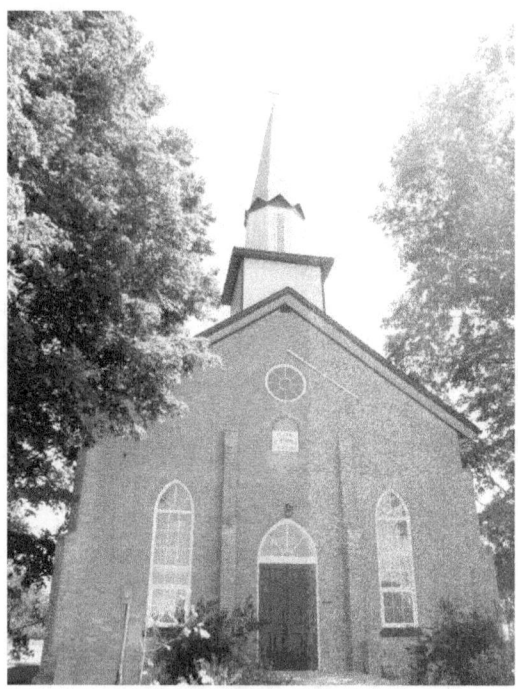

St. Peter's Lutheran Church

www.ingramcontent.com/pod-product-compliance
Lightning Source LLC
Chambersburg PA
CBHW061522180526
45171CB00001B/295